The West Country

D0547678

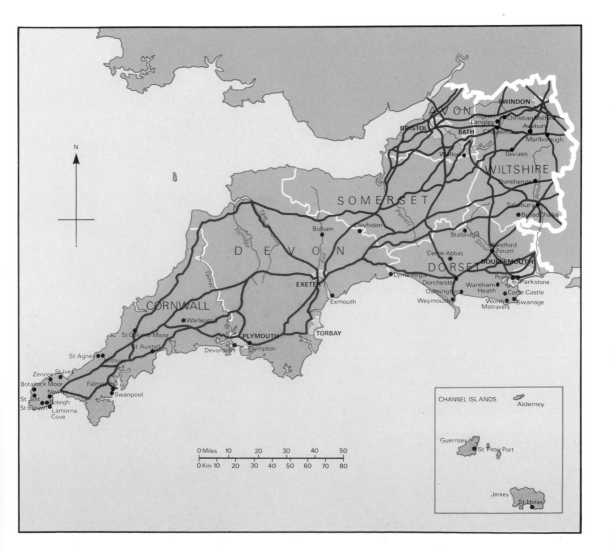

INTRODUCTION

More artists have come to live in the West Country than in perhaps any other provincial part of Britain. In the eighteenth century the fashionable spa town of Bath exerted an obvious attraction for society portraitists such as Gainsborough. Later the centre of artistic activity shifted to Bristol, where there grew up one of the most distinguished regional schools of British painting. Although this comprised mainly indigenous artists, it should be noted that its most famous and gifted member, Francis Danby, came from Ireland.

The large-scale migration of artists to the West Country, however, dates from comparatively recent times. From the 1880s a large number of painters began to settle in the fishing village of Newlyn. The rugged Celtic peninsula of Cornwall, with all its legends and superstitions, had close affinities with one of the most fashionable artistic centres of the late nineteenth century – Brittany. One of the first painters to arrive in Newlyn, Stanhope Forbes, was primarily attracted by its physical and spiritual kinship with the Breton village of Concarneau, where, like many British artists of his time, he had spent a formative period of his youth. Although Cornwall could not boast the quaint folk-costumes of Brittany, the Newlyn School artists found a rich source of subjects in the hard but picturesque lives of the local fisherfolk.

Stanhope Forbes, who was always the most important of the Newlyn painters, continued to work in the village until 1940, by which time his realistically painted genre scenes must have seemed reactionary even in a British context. The vital role once played by Newlyn in British art had by this date been usurped by the neighbouring village of St Ives. From the very start the artists who went to St Ives were more interested in landscape than in figure painting; and this preoccupation can be traced right up to the 1950s, when the village became internationally famous as a leading centre of abstract art.

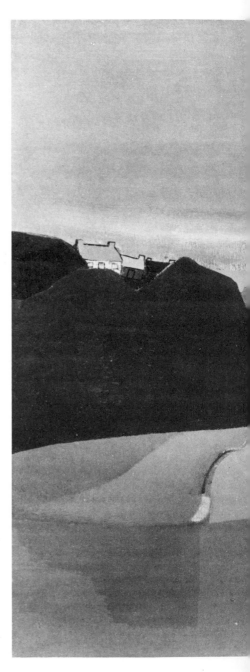

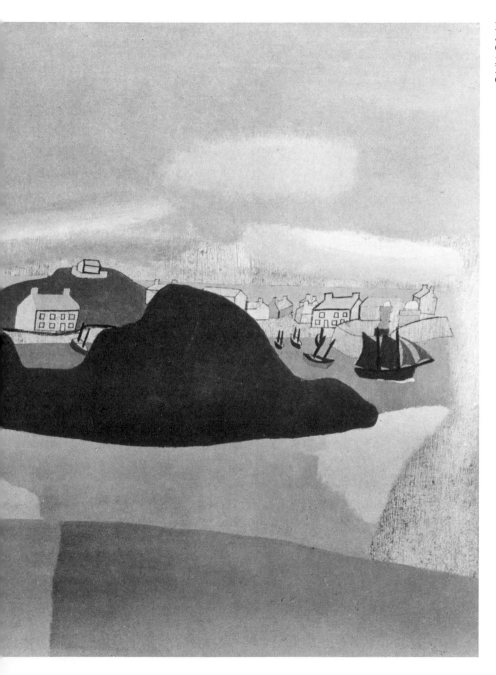

Ben Nicholson
St Ives, 1940
Oil on canvas,
32·4 × 39·1 cm
Reddihough
Collection

Avebury, *Wilts.*

While recovering from a serious attack of bronchitis, Paul Nash stayed with friends at Marlborough throughout the summer of 1933. It was during this stay that he discovered the prehistoric stones of Avebury. Their impact brought with it an increased interest in the past and its mysteries, which is mirrored in his subsequent paintings. Nash never depicted the stones naturalistically, and reduced them, as he did in his first Avebury painting *Equivalents for the Megaliths*, to precise geometrical forms.

Bath, *Avon*

During its heyday as an aristocratic resort, Bath was a centre for portrait painting. The most celebrated artist actually to settle here was Thomas Gainsborough, who came to

Thomas
Gainsborough
Captain Wade,
Master of
Ceremonies at Bath
1771; oil on canvas,
250 × 165 cm
Private collection,
currently on loan to
Birmingham City
Art Gallery

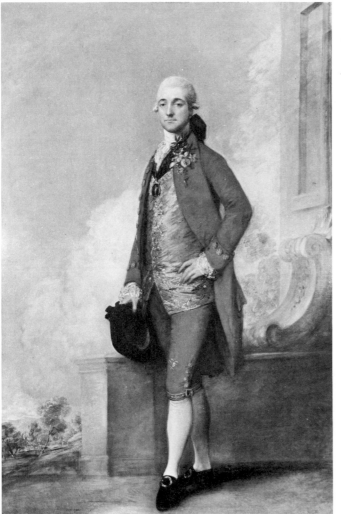

Bath from his native Suffolk in 1759 and stayed for fifteen years. His places of residence are difficult to locate exactly. By 1766 he was living in Lansdowne Road, and in that year he moved to The Circus, where he remained for the rest of his 'Bath period'; which particular houses were his is not known. Gainsborough painted a large number of his dashingly executed portraits here, but none is more evocative of the world of high fashion associated with eighteenth-century Bath than *Captain Wade*, a likeness of the city's Master of Ceremonies. One of the artists who set up in Bath in the hope of taking over Gainsborough's clientèle was Joseph Wright of Derby; he arrived in 1775 and left, unsuccessful, two years later. Another was Thomas Lawrence, whose family moved into No. 2 Alfred Place (plaque), near the Assembly Rooms, in 1780, when the artist was eleven. Lawrence's father had recently abandoned his career as a landlord (see *Bristol* and *Devizes*) and Lawrence himself was now providing the mainstay of the family income, though still only adolescent. After seven years the family moved to London, where he could attract more lucrative commissions.

Thomas Barker of Bath was a landscape-painter working here partly under Gainsborough's influence. Though relatively little known today, in his time Barker was rich and successful. He was based in Bath from 1800 until his death in 1847, living from about 1810 at Doric House on Sion Hill; this survives and there is a landscape mural by Barker on the ground floor.

Walter Sickert spent the summers of 1916, 1917 and 1918 at Bath, staying latterly in a small house above Camden Crescent. In 1937 the aged artist returned to Bath and bought St George's Hill House at Bathampton, where he died five years later. When in the city, he loved to paint Pulteney Bridge; the combination of water and architecture reminded him of his beloved Venice.

In 1946 the Bath Academy of Art moved from the city itself to Corsham Court, ten miles to the north-east off the Chippenham road. Under the directorship of Clifford Ellis it became one of the leading art schools in the country. Its greatest period was in the late 1940s and early 1950s, when Kenneth Armitage was head of the sculpture department and William Scott was Senior Painting Master. Many of the artists invited to teach at Corsham during the school's first decade – such as Peter Lanyon, Terry Frost

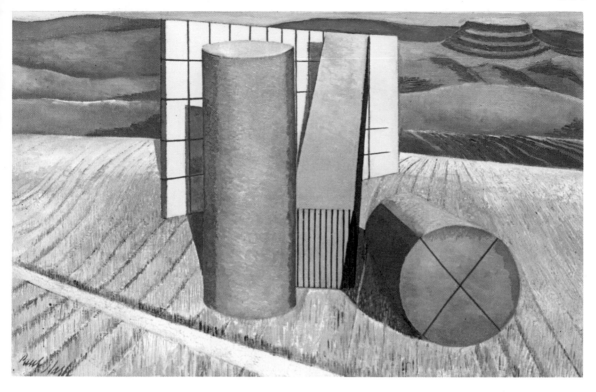

and Bryan Wynter – were abstract artists associated with St Ives; the Bath Academy provided them with an ideal forum for the discussion and dissemination of their ideas.

Blandford Forum, *Dorset*

Alfred Stevens, the Victorian designer, sculptor and painter, was born in Blandford in a courtyard house (demolished) behind 38 Salisbury Street (plaque). His father was a joiner, decorator and heraldic painter, and Stevens was apprenticed to him at the beginning of his career. He was soon taken up by local patrons, however, most notably the Hon. Samuel Best, Rector of Blandford St Mary, who encouraged him to go to Italy to study art. Stevens remained in Italy between the ages of fifteen and twenty-four, earning a living mainly by sketching portraits. On his return he spent a further two years in Blandford. During this time he produced a series of bas-reliefs after designs by the Danish sculptor Thorwaldsen for overdoors in Chettle House, seven miles north-east of the town. In 1844 Stevens moved to London, where he worked largely as a decorative designer in a style based on his study of Italian Renaissance art. His greatest achievement is the Wellington Memorial in St Paul's Cathedral.

Botallack Moor, *Cornwall*

Roger Hilton had a small cottage on Botallack Moor from 1965 until his death in 1975. He was very ill for the last years of his life, and most of his late works were done in bed. Hilton was by nature a quiet, retiring man, but a combination of drink and growing fame had by this time turned him into a ferocious, outspoken wit. His lack of concern for the tidiness of his surroundings (the walls of his cottage are still covered with his scribblings), or even with conventional sanitation, was reflected in his attitude towards art: 'Throughout my life I have always maintained that you do not need complicated and expensive apparatus to produce a work of art. You could go in the backyard and scrape up some mud and put it on some board the builders had left behind; art, by and large, is in the mind.'

Bristol, *Avon*

In 1769 the portraitist Thomas Lawrence was born in Bristol at No. 6 Redcross Street (gone). His father was a Supervisor of Excise who later took up as an innkeeper at the White Hart (gone) in Broad Street. The family moved to Devizes (q.v.) when the artist was four years old. Apart from

Paul Nash
Equivalents for the Megaliths
1935; canvas, 45·7 × 66 cm
Tate Gallery, London

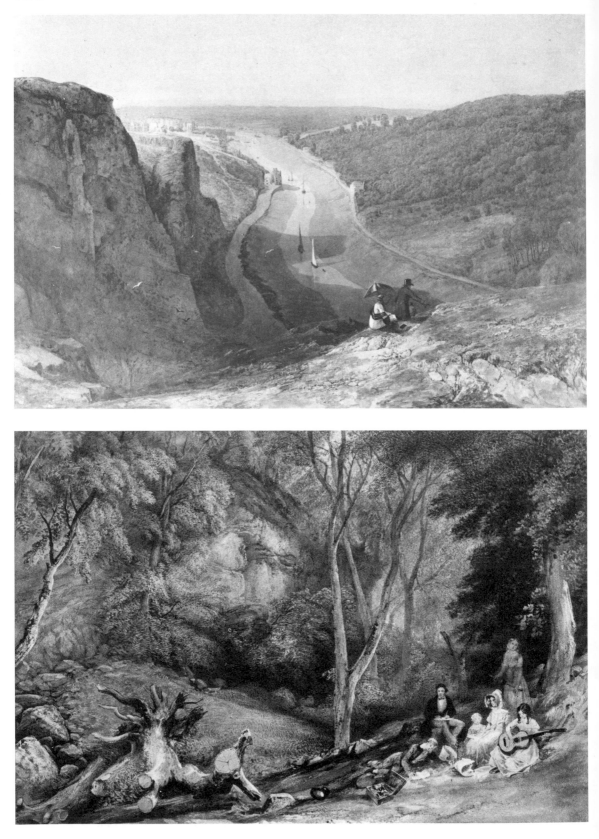

Lawrence, no artist of national reputation originated from or worked in Bristol before the nineteenth century. After 1810, however, the beginnings of a coherent 'Bristol School' can be traced in the activities of a circle of artists and amateurs centred on the Royal Academician Edward Bird. These would meet regularly for the purposes of sketching, both indoors and out, and conversing on artistic matters. In 1817 the Irish-born Francis Danby moved to Bristol. He soon became associated with the group and joined them in their evening sketching sessions, during which they produced imaginary landscapes in monochrome wash, often with fantastic architecture and exotically dressed figures.

Danby's Bristolian friends also introduced him to the delights of the local scenery, and the paintings of Leigh Woods, Nightingale Valley and Stapleton Glen which he produced in the 1820s are an expression of the whole group's poetic approach to nature. The Reverend John Eagles, an amateur artist of the group who seems to have coined the term 'Bristol School' in 1826, recalled the artists' outings in *The Sketcher*, published in 1856. This nostalgic account provides an insight into the ideas behind Danby's Bristol land-scapes; in it Eagles compares Leigh Woods with 'the regions of Elysium' and advocates that a landscape should be 'a poetical shelter from the world'. The sites along the Avon and the Frome that were painted by the Bristol School remain in many cases much as they were. In Stapleton, for example, Wickham Bridge and the area around the now ruined Snuff Mills (a public park) are still highly picturesque, and both Nightingale Valley and Leigh Woods are visited as beauty-spots.

Bird died in 1819, and by the early 1820s Danby was clearly the dominant artist of the Bristol School. In spite of this, he seems never quite to have settled down in the city; he moved house frequently and left Bristol altogether in 1824, heavily in debt. Danby had a taste for the epic as well as the idyllic, and tackled spectacular subjects such as *The Opening of the Sixth Seal* and *The Delivery of Israel out of Egypt*. His most notable Bristolian follower in this kind of work was Samuel Colman, a painter of limited technical skill, but of an extraordinary, apocalyptic imagination. But the most gifted among Danby's contemporaries in Bristol was Samuel Jackson. In contrast to Danby, Jackson remained here, earning a good living as a drawing-master and painter

OPPOSITE, ABOVE:
Francis Danby
The Avon Gorge
Early 1820s;
watercolour
heightened with
white, 46 × 74 cm
Private collection

OPPOSITE, BELOW:
Samuel Jackson
*A Sketching Party
in Leigh Woods*
1820s; watercolour
and bodycolour,
44.1 × 65.7 cm
Bristol Museum and
Art Gallery

Francis Danby
*The Frome at
Stapleton*
Early 1820s; pencil,
watercolour and
bodycolour, 20 ×
30.2 cm
Bristol Museum and
Art Gallery

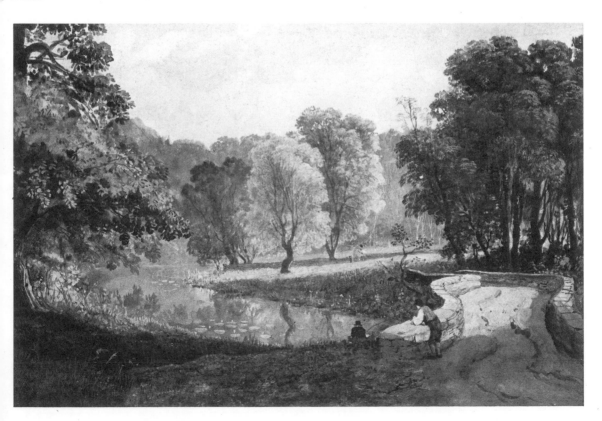

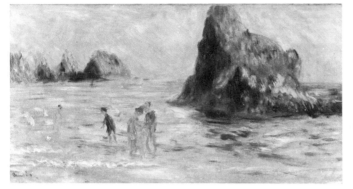

Auguste Renoir
*Cradle Rock,
Guernsey*
1883; oil on canvas,
29·2 × 54 cm
National Gallery,
London

of topographical watercolours, and set up a comfortable and respectable home, at No. 3 Cotham Vale.

Bristol's most famous native artist had little contact with the Bristol School and indeed is known mainly for his oriental scenes. William James Müller was born in Hillsbridge Parade in 1812; he lived later on College Green, and then in what is now the White Harte pub in Park Row. He died young in 1845.

Living in the city today is the 'land artist' Richard Long. Much of Long's work has been inspired by West Country landmarks, such as the Avon Gorge (from which he has extracted and arranged driftwood), the ithyphallic Cerne Abbas Giant in Dorset, and the wilder expanses of Dartmoor. He has a romantic fascination with the primeval element in the environment.

The Channel Islands

The Victorian artist John Everett Millais came from an old Jersey family and spent much of his childhood on the island before going to study art in London at the age of nine. Though born in Southampton, he always insisted upon the title of Jerseyman, protesting that 'being born in a stable would not make me a horse'.

One of the most interesting artists associated with the Channel Islands is far more celebrated as a writer. Victor Hugo lived in Jersey, at Marine Terrace (gone) on Grève d'Azette in St Helier, from 1852 to 1855. He then moved to Hauteville House, St Peter Port, Guernsey, where he remained until returning to France in 1870. The house is now open to the public and contains examples of his highly distinctive wash drawings, in which he employed a wide range of sources and techniques to create powerful, often nightmarish images.

The Impressionist painter Auguste

Renoir visited Guernsey in September 1883 and made a number of landscapes. 'I am here on a charming beach completely different from our Norman beaches', he wrote in a letter to a dealer friend; '. . . it seems more like a landscape by Watteau than something real.'

Chippenham, *Glos.*

Kington Langley, just outside Chippenham, is the home of the etcher Robin Tanner. The idyllic country scenes that have earned him his considerable popular reputation are all based on sites around the village. Joe Tilson, an artist of a younger generation, lives near by at Christian

Francis Danby
*A View of the Avon
Gorge*
1822; oil on panel,
34·6 × 46·7 cm
Bristol Museum and
Art Gallery

Richard Long
*River Avon
Driftwood*
1976
Tate Gallery,
London

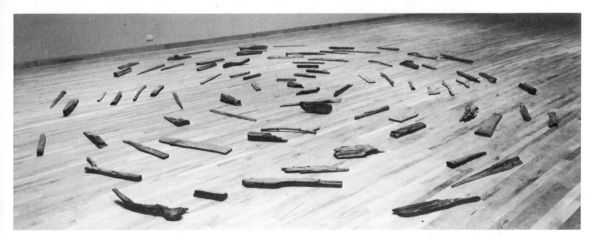

Robert Bevan
Rosemary
1922; lithograph,
23·8 × 29·2 cm
Maltzahn Gallery,
London

Malford. Many of his works, such as his poem-ladders, have an intellectual, as opposed to representational, relationship with the natural environment; and he often places or photographs them in his garden.

Clayhidon, *Devon*

Applehayes, a farm on the Devon-Somerset border, belonged to Harold B. Harrison, a retired rancher from Argentina who in old age enrolled himself at the Slade School of Art in London. From 1910 onwards he invited artists whom he liked and admired to come and spend painting holidays at Applehayes, and special studios were built for the purpose. The most notable of his guests were the Camden Town painters Spencer Gore, Charles Ginner and Robert Bevan. It is Bevan who is most remembered for landscapes painted around the farm, in particular his *Rosemary* canvases of 1915 onwards. In contrast to his Applehayes landscapes, painted in a much freer style, these reflect the influence of the famous

Post-Impressionist exhibitions organized by Roger Fry in London. The surrounding Blackdown Hills are reduced to geometric simplicity, and Bevan was very pleased when the village postman said of one of these works, 'That field is laid out beautiful.' Wartime conditions made it difficult for Harrison to continue his hospitality, and in 1916 Bevan rented a cottage himself. This was in the Bolham Valley, deeper still in the heart of the Blackdown Hills, where he had begun to feel so much at home.

Corfe Castle, *Dorset*

The most important New Zealand-born artist of this century, Frances Hodgkins, lived mainly at Corfe Castle from 1939 to 1947, the year of her death. Arriving in Europe in 1901, aged 32, she led a peripatetic existence, spending much of her time in France; here she came heavily under the influence of contemporary French painting, in particular that of Matisse. At Corfe Castle she used as her studio a

converted chapel near the Fox Inn on West Street. Hodgkins lived the life of a virtual recluse, and suffered great poverty. Her end was also a tragic one. While staying at the Greyhound Inn in the village she began to have dreadful hallucinations, and her screams throughout the night eventually led to her being certified insane. Her last weeks were spent in pathetic circumstances at the Harrison Mental Institution near Dorchester, where only on the intervention of her great admirer Julian Huxley was she isolated from the other patients. She died shortly afterwards.

Devizes, *Wilts.*

Between 1773 and about 1779, the landlord of the Bear Inn in Devizes marketplace was the father of Thomas Lawrence. As a boy Lawrence was a famous prodigy and would entertain guests at the inn by sketching their portraits and reciting poetry. The Bear was frequented by many aristocratic travellers on the route between London and Bath, and the reputation that Lawrence established among them stood him in good stead when he later came to set up as a fashionable portraitist in Bath itself (q.v.).

Devizes is today the home of three members of the Brotherhood of Ruralists, a group of artists working in the English tradition of poetic landscape painting. David Inshaw moved here from Bristol in 1971; he was joined in 1974 by his friends Graham and Ann Arnold and they are now next-door neighbours in Lansdowne Terrace. They take much of their inspiration from the local landscape, its forms and its associations.

Exeter, *Devon*

Exeter was the birthplace of the famous miniaturist Nicholas Hilliard, who held the office of Limner (i.e. Painter) and Goldsmith to Queen Elizabeth 1. His father, Richard Hilliard, had a shop in Goldsmith Street, but the family lived in the parish of St George (the area of the market, which was badly damaged in the last war).

Two prominent eighteenth-century artists were born in Exeter but spent most of their lives in London. These were Thomas Hudson, portraitist and master of Joshua Reynolds (see *Plymouth*), and Francis Hayman, who is chiefly known for his decorative paintings for Vauxhall Gardens. By contrast, the watercolourist Francis Towne chose to remain in his native city for the best part of his career, earning his living

as a drawing-master and painter of local landscapes and country-house views. Towne's most distinguished pupil and imitator was John White Abbott. Though exhibiting frequently in London, Abbott never became a professional painter, but spent his whole life in Exeter, where he practised as a surgeon.

Exmouth, *Devon*

Though more familiarly associated with Bristol (q.v.), Francis Danby spent the last fourteen years of his life in Exmouth. From 1847 to 1856 he lived in Rill Cottage in North Street, adjacent to what is now called Danby Terrace. He then moved to Shell House, on a piece of land facing the estuary

John White Abbott *Near the Quay, Exeter* 1803; watercolour, 17 × 10.2 cm Royal Albert Memorial Museum, Exeter

OVERLEAF: David Inshaw *She Did Not Turn* 1974; oil on canvas, 138 × 183 cm Private collection

of the Maer, where he remained until his death in 1861 (both houses have been demolished). He is buried in the church of St John-in-the-Wilderness.

Falmouth, *Cornwall*

Henry Scott Tuke was brought up in Falmouth, in houses in Florence Terrace and Woodlane. At the age of twenty-seven, after his artistic training was over, Tuke took a cottage at Swanpool (gone) and would regularly spend his summers working in and around Falmouth, where he owned a studio-boat. Tuke's favourite subject, to which he returned again and again, was that of lithe and generally naked adolescent boys in a sunny setting by the sea. These he painted with a vivid impressionistic technique. Falmouth Art Gallery contains a showcase devoted to his life and work, and there is a collection of his paintings at the Royal Cornwall Polytechnic Society.

Lamorna Cove, *Cornwall*

The first artist to come to Lamorna was John Birch, who later changed his name to Lamorna Birch to avoid confusion with a

Henry Scott Tuke
The Bathers
1889; oil on canvas,
116·8 × 86·3 cm
Leeds City Art
Gallery

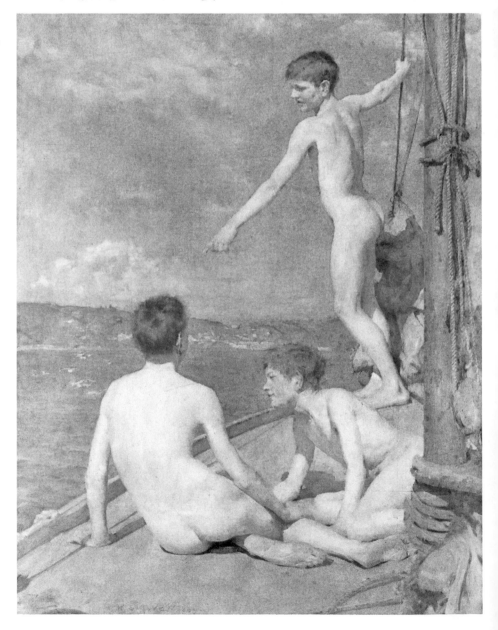

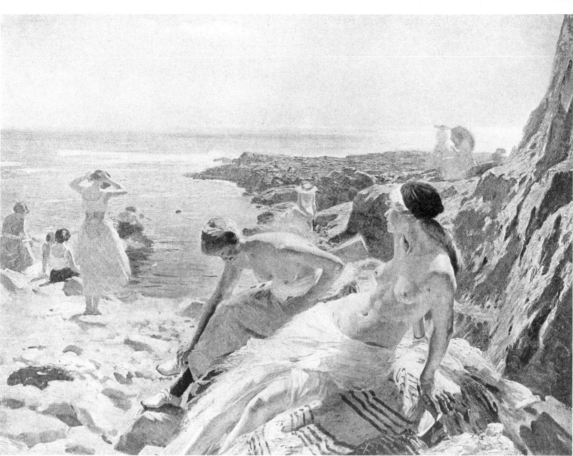

Laura Knight
Daughters of the Sun
1910–11; oil on
canvas; size and
location unknown

namesake working at Newlyn. When he came here as a young art student about 1890, he lodged at a farmhouse at Boleigh. He moved permanently to Lamorna in 1902 and shortly afterwards bought Flagstaff Cottage, an old harbourmaster's house overlooking the bay; this is now kept by his daughter, Lamorna Kerr, who shows some of Birch's works, and also her own, to interested visitors. In the wooded valley of Lamorna, Birch had two studios (both surviving), one of which is close by the stream. The latter features constantly in his paintings; he was a keen fisherman, and excelled in portraying running water.

Other notable artists to have worked in Lamorna include Harold and Laura Knight. The Knights arrived in Cornwall in 1910, staying first at Newlyn (q.v.) but making regular painting trips to Lamorna, as well as visits to Lamorna Birch. On one occasion Benny Leader, the son of the well-known painter Benjamin Williams Leader, lent them a cottage on the hill by Lamorna Gate, and it was while staying here that Laura painted *Daughters of the Sun*, the most ambitious of a series of studies of scantily dressed girls lying by the sea. These were all painted on the rocks beyond Lamorna Cove, where the local squire, Colonel Paynter, had a studio built for her. To pose naked out of doors was quite a novelty in those times, but the two London models employed for the purpose showed few inhibitions, even going for nude swims between poses. The local curiosity and indignation that these antics aroused came to a head when two old ladies, on an annual outing from Newlyn, caught sight of Laura Knight painting a naked man. Colonel Paynter was immediately informed but defended the artist, saying that as she was painting on his land, she could do what she liked. The benevolent Colonel later converted a series of cottages into one long house for the Knights, called Oakhill, where they lived from 1912 until 1919. Most visitors to Lamorna at this time stayed at the village's so-called Temperance Hotel (now largely rebuilt as the Lamorna Cove Hotel). A frequent guest there was Alfred Munnings, whose brash and extrovert manner, and constant attentions to women, earned him the admiration of Laura

Knight, but the considerable antipathy of Harold.

Two strong individualists of British art who have both been labelled surrealists have also been associated with Lamorna: John Armstrong and John Tunnard. Armstrong moved to Lamorna in 1947 and remained here until 1955. The house where he stayed, Oriental Cottage, was where Dylan Thomas had flirted with Caitlin Macnamara in June 1937. Tunnard came to Cornwall during the Second World War, living first at Cadgwith in a horse-drawn gypsy caravan, moving in 1947 to Garden Mine Cottage at Morvah Hill – a lonely house built of granite masonry salvaged from an abandoned tin-mine – and finally settling in 1952 at Trethinnick in the Lamorna Valley, where he stayed until his death in 1971. Trethinnick was a house and studio once used by the Knights. Tunnard's purchase of the house was followed by a radical transformation of the surroundings, in which task he revealed himself as an outstanding landscape gardener. His other passions were entomology and jazz. He invariably painted to jazz accompaniment, and the near-abstract forms of his innovatory canvases were influenced by its rhythms. As independent in his lifestyle as in his art, Tunnard always worked alone at Lamorna in a small corrugated-iron shack (still surviving) in a secluded spot by the valley stream.

John Tunnard's studio, Lamorna Cove

Lyme Regis, *Dorset*

The American-born artist James Abbott McNeill Whistler spent the autumn of 1895 in Lyme Regis, staying in a first-floor room at the Red Lion Hotel and working in a studio a few doors away up Broad Street (now a carpenter's shop, behind a tobacconist's). He produced a large number of lithographs here, mostly of scenes in and around a nearby smithy, and several paintings, including a portrait of a local girl entitled *Little Rose of Lyme Regis*. The Philpot Museum contains mementos of the artist's stay, notably presents he gave to Rose.

Newlyn, *Cornwall*

'Here every corner was a picture, and, more important from the point of view of the figure-painter, the people seemed to fall

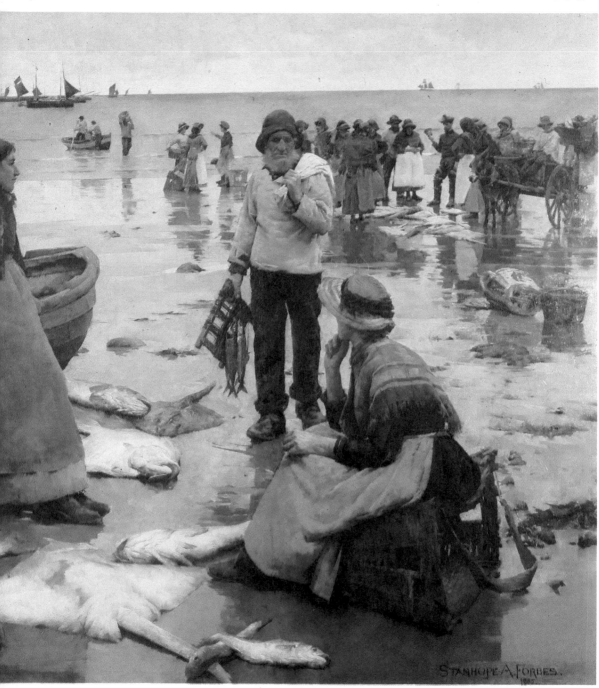

naturally into their places, and to harmonise with their surroundings.' Such was Stanhope Forbes's first impression of the Cornish fishing village where he was to spend most of his working life.

Forbes arrived in Newlyn in 1884. Although he was not the first artist to 'discover' the place, he was undoubtedly the most gifted; when other painters such as Frank Bramley, Thomas Cooper Gotch and Norman Garstin followed him here, and a 'Newlyn School' came to be spoken of, Forbes was universally acknowledged as its central figure. What he and the other Newlyners shared was a debt to French art, and indeed one of the initial attractions of Cornwall was its similarity to Brittany, where several of them had studied and worked. (In fact the village is now twinned with the former Breton art colony of

Stanhope Forbes
A Fish Sale on a Cornish Beach
1885; oil on canvas, 121·5 × 155 cm
Plymouth Art Gallery

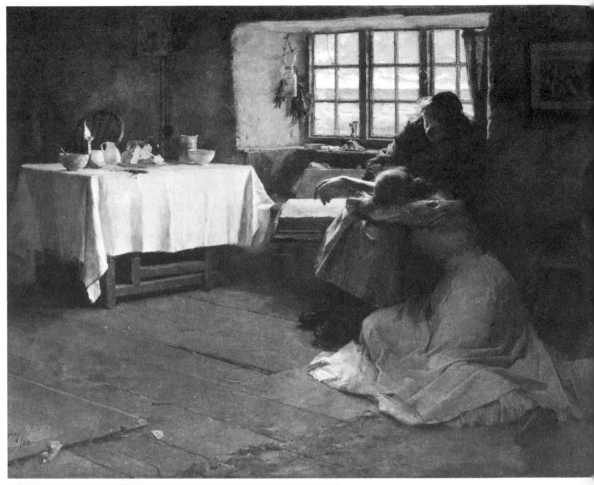

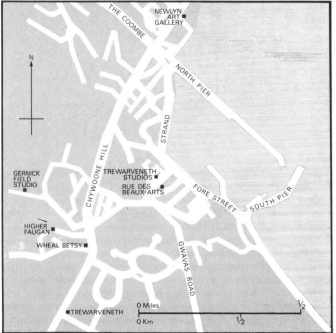

Concarneau.) More specifically, they were influenced by the style of *plein-air* naturalism practised by Bastien-Lepage, whom Forbes once called 'the greatest artist of our age'. For their subject-matter they looked to the inhabitants as much as to the village itself, and their work shows a strong interest in the everyday life of the fishermen and their families.

Forbes and his wife, who was also a painter, had various homes and studios in Newlyn, most notably Trewarveneth, an extended cottage at the top of Paul Hill. This and an alley in the village nicknamed 'rue des Beaux-Arts' were the centres of Newlyn's thriving artistic community. The population of painters was further increased in 1899 when the Forbeses set up a school, which attracted students from all over the world. The most successful of these were Dod Shaw and Ernest Procter, who married one another and became leading representatives of the Newlyn School in their own right. The Forbeses

lived at Trewarveneth for thirteen years before moving in 1904 to the more imposing Higher Faugan (now a hotel), which was built to the artists' own designs and stands on the hill above the village.

After Forbes, the most celebrated Newlyn artist is Frank Bramley, whose famous picture *A Hopeless Dawn* was painted in a tiny studio in the 'rue des Beaux-Arts'. Portraying the effect of a shipwreck on the fishermen's families, Bramley uses a dramatic chiaroscuro typical of the Newlyners' treatment of interior subjects. Another of the more notable artistic settlers was Norman Garstin, who painted Newlyn scenes and views on the seafront at Penzance, near his home at 4 Wellington Terrace. Works by the Forbeses, Bramley, Garstin and other members of the Newlyn School can be seen at Newlyn Art Gallery and also at the Queen's Hotel on the coastal road between Newlyn and Penzance.

Thomas Cooper Gotch stood stylistically far apart from realists like Forbes, Bramley and Garstin, and specialized in pictures of beautiful children, usually painted naturalistically but in incongruously stylized settings. Gotch succeeded the Forbeses at Trewarveneth and later moved to a grander residence called Wheal Betsy, down the hill towards the village. Wheal Betsy and its grounds, including a spacious studio in

corrugated iron, were until recently exactly as Gotch left them (he died in 1931) and even now they remain much as they were.

Harold and Laura Knight were latecomers to Newlyn, moving here from Staithes, on the Yorkshire coast, in 1910. Laura had admired the Newlyn School since seeing an exhibition of their work in Nottingham during her student days; she remembered being particularly moved by *A Hopeless Dawn*. Though at first they missed Staithes, she and Harold soon came to feel at home in Newlyn thanks to Stanhope Forbes, who introduced them into the artists' community. After a short time in lodgings they moved into Trewarveneth, succeeding Gotch, but in 1912 they decided to move again, this time to Lamorna Cove (q.v.).

Trewarveneth Studios, which were built in the 1880s by a minor artist named Costa and later occupied by several members of the Newlyn School, including Stanhope Forbes, are now used by the sculptor Denis Mitchell and the abstract painter John Wells. Another artist in Newlyn today is Terry Frost, who lives at Gernick Field Studio, Tredavoe Lane. Closely associated with St Ives (q.v.) in the 1950s, Frost returned to the West Country in 1974 after spending a number of years in Leeds and Reading.

OPPOSITE, ABOVE:
Frank Bramley
A Hopeless Dawn
1888; oil on canvas,
122 × 167·8 cm
Tate Gallery,
London

BELOW:
Newlyn

Norman Garstin
The Rain It Raineth Every Day
1889; oil on canvas,
94 × 162·7 cm
Penzance Charter
Trustees

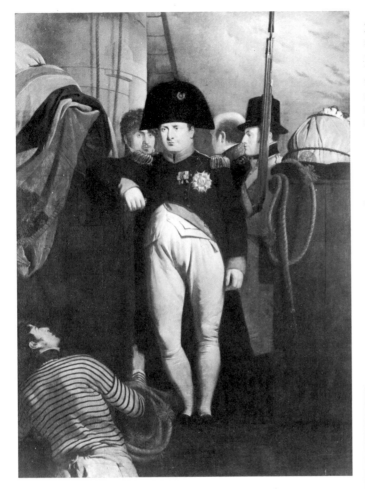

James Northcote was the son of a Plymouth watchmaker. Though initially apprenticed to his father, Northcote showed artistic gifts that led to his being sent up to London in 1771 for professional training. He was provided with a letter of introduction to Reynolds, who took him in as a boarder in his own house for five years and instructed him in painting. Following in Reynolds's footsteps, Northcote subsequently studied in Rome and then established himself in London as a leading portraitist and historical painter.

Though both sons of Plymouth book-sellers and lifelong friends, Benjamin Robert Haydon and Samuel Prout were artistically poles apart. Prout was content throughout his career to produce humble topographical watercolours, most notably of French churches. Haydon saw himself as a painter in the grand manner extolled in Reynolds's *Discourses*. At eighteen he became a student at the Royal Academy, and, except for a short period of work as a portraitist in Plymouth, remained in London for the rest of his life. At first he enjoyed considerable success, which was recognized by his

Charles Lock Eastlake
Napoleon on Board the 'Bellerophon' in Plymouth Sound
1815; oil on canvas, 260 × 184 cm
National Maritime Museum, London

Plymouth, *Devon*

In the eighteenth century Plymouth produced an extraordinary succession of highly literate painters, whose writings are as well known today as their pictures. The first and greatest was Joshua Reynolds, son of the Reverend Samuel Reynolds, Master of Plympton Grammar School (still standing in Plympton St Maurice, although the original schoolmaster's house was rebuilt in 1871). After attending his father's school, Reynolds was apprenticed to the Exeter-born portraitist Thomas Hudson, in London. But at twenty he returned home and set up his own portrait practice in Dock (Devonport), working mostly for local gentry and naval and military officials. Five years later he left for a period of study in Italy, and after his return to England lived permanently in London. Reynolds became the first President of the Royal Academy and his famous *Discourses* dominated art theory in this country well into the nineteenth century.

election to the freedom of his native town in 1814. But two factors inevitably contrived against him: the lack of patronage in England for anything but portraits and landscapes, and the fact that his ambition far outstripped his talent as an artist. Haydon's depressing career, which ended in suicide, is documented in voluminous published diaries. These vividly convey his unstable personality and acute sense of injustice towards himself.

Another Plymouth-born painter was Charles Lock Eastlake, the son of a judge-advocate and solicitor to the Admiralty. Following the pattern established by Reynolds, Eastlake trained in London, in Haydon's studio and at the Academy Schools, and then returned to his native town as a portrait-painter working for a local clientèle. In 1815 he seized the opportunity of painting *Napoleon on Board the 'Bellerophon' in Plymouth Sound*. This was based on a sketch made in a small boat moored near the *Bellerophon* during its short stop here en route for St Helena. Seeing Eastlake at work, Napoleon held a pose and had a uniform and decorations sent ashore for the young artist's use. The picture was a great success and provided funds for Eastlake to travel in Europe. He remained abroad for fourteen years and acquired a grounding in the history of art which served him not only as a painter but also as a scholarly writer and an administrator. He settled in London from 1830, and by the end of his life held both the Presidency of the Royal Academy and the Directorship of the National Gallery.

Poole, *Dorset*

Augustus John and his second wife, Dorelia, moved from Chelsea to Alderney Manor in Parkstone, on the outskirts of Poole, in the summer of 1911; it was their first home of any permanence, and they stayed here until 1927. The house and its sixty acres of beautiful woodland have now been replaced by a housing estate.

The life led by the Johns at Alderney Manor was characteristically eccentric, and a constant source of speculation to the neighbours. The unending succession of Augustus's girlfriends coming to visit the

Augustus John
Lyric Fantasy
1910–11; oil on
canvas, 234 ×
470 cm
Tate Gallery,
London

John Opie
A Gentleman and a Miner: Captain Morcom of Polperro Mine, St Agnes, showing a specimen of copper ore to Thomas Daniell of Truro
1786; oil on canvas, 99 × 124·5 cm
Royal Institution of Cornwall

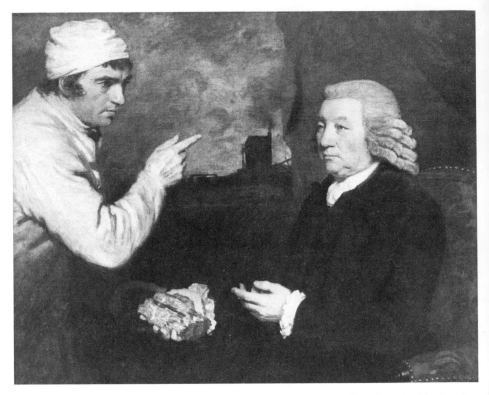

house appears to have left Dorelia completely unperturbed. She for her part continued an affair with the painter Henry Lamb, who conveniently lived near by in Poole, and with whose beautiful wife, Euphemia, Augustus himself had once become entangled. After his first visit to Alderney Lamb wrote enthusiastically to his friend Lytton Strachey: 'She [Dorelia] lives in an amazing place in a vast secluded park of prairies, pine woods, birch woods, dells and moors with a house, cottages and a circular walled garden. . . . It was very hot when I was there and lovely naked boys running about the woods.' Alderney's strange, almost magical atmosphere must have been heightened by the colourful clothes Dorelia made for herself and for the growing number of John's children.

When John moved into Alderney Manor he was at the height of his creative powers. The previous year he had painted a series of engaging and spontaneous studies at the Provençal fishing-port of Martigues; in these, members of his family had been shown as vivid patches of colour against a sensuous Mediterranean background. He continued in this Martigues manner in his early years at Alderney but now used both his own garden and the surroundings of Dorset as settings. Nearby Wareham Heath, where there are a number of small lakes occupying the site of old claypits, appears, freely interpreted, as the background of the culminating work of this period, the *Lyric Fantasy* now in the Tate Gallery.

St Agnes, *Cornwall*

Just to the east of St Agnes lies the hamlet of Mithian, birthplace of John Opie. Opie's father was a mine carpenter of Blowing House (now known as 'Harmony Cot' and marked with a plaque) and Opie himself was apprenticed to a local wheelwright, until his precocious talent for drawing was discovered by the Truro writer Dr John Wolcot. Wolcot helped to educate Opie and to launch him upon his career as a professional artist. Opie worked locally as a portraitist for a period in the late 1770s, but in 1780 or 1781 he was taken by Wolcot to London. There he established a reputation, first as a prodigy ('the Cornish wonder'), then as a mature artist of considerable standing.

St Buryan, *Cornwall*

At Treverven House, near St Buryan on the B3315, lived Bryan Wynter (see *St Ives and Zennor*) from 1964 until his sudden death in 1975. The most interesting abstract paint-

ings of his career date from three years after his move to Treverven. In them a new-found clarity and love of pure colour evoke all the rich, mysterious quality of water, with its ripples and brilliant reflected light. These paintings carry such titles as *Meander*, *Confluence*, and *Stream*. His artistic interest in water was accompanied by a love of underwater swimming, and, above all, canoeing, by which means he intrepidly explored almost all of Cornwall's coastline and rivers.

St Columb Major, *Cornwall*

It was in and around the village of St Columb Major that the Yorkshire-born artist Sir Matthew Smith painted a series of uncompromisingly original landscapes that were milestones in contemporary British art. Smith had spent the summer of 1920 with his wife and children at the coastal resort of St Austell. It had rained a great deal and Smith had been unable to do much painting. His move in the autumn to St Columb Major followed his family's return to London. At last, left on his own, he gradually began to feel that he was 'getting somewhere'. Apart from one short break he remained at St Columb Major until early the following year. The austere setting of the village, together with the dark granite of

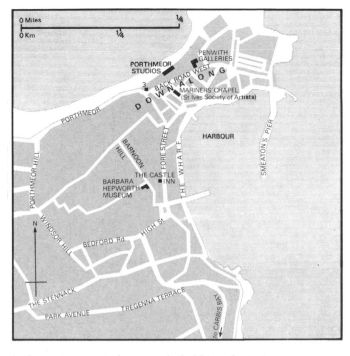

St Ives

its houses, seems to have reminded him of his beloved Brittany; and the landscapes done here owe much to Gauguin, even down to the tinted signature *M. S.* The imaginative use of sombre colours, as in the Tate Gallery view of the village church

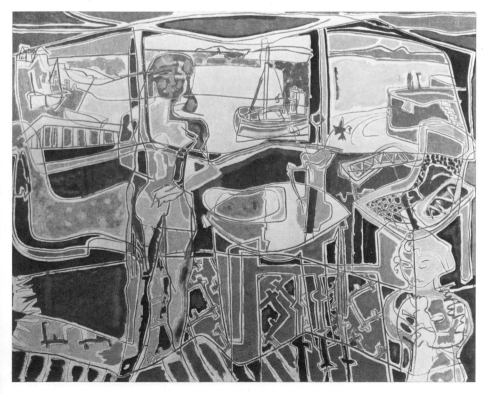

Patrick Heron
*Harbour Window
with Two Figures:
St Ives: July 1950*
Oil on hardboard,
121·9 × 152·4 cm
Private collection

Matthew Smith
Cornish Church
1920; oil on canvas,
53·3 × 64·8 cm
Tate Gallery,
London

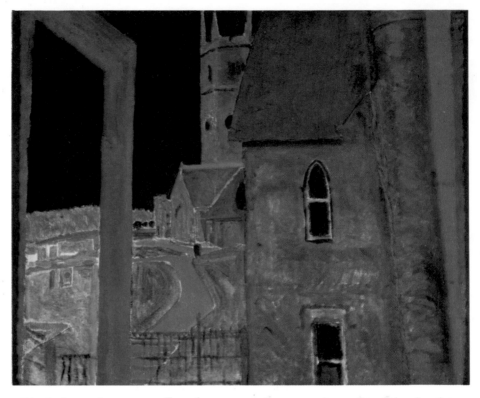

painted from the room where he was staying, gives these works a brooding, febrile quality.

St Ives, *Cornwall*

The importance of St Ives as an art colony dates back to the winter of 1883–4, when Whistler and Sickert spent several weeks working in the town. It was about this time that part of an extensive series of sail lofts along Porthmeor Beach was converted into studios. These were to be used by some of the most important St Ives artists, including Julius Olsson, Ben Nicholson, Terry Frost, Roger Hilton, Patrick Heron and Patrick Hughes. From the very start, the old fishing quarter of Downalong, where the Porthmeor Studios were situated, became the nucleus of the artists' colony. The best-known artist of this early period is Julius Olsson, who ran a school for marine painting and who produced some of his famous nocturnal seascapes in what is now No. 5 Porthmeor Studios. It was one of Olsson's students, Borlase Smart, who played the major part in revitalizing the colony after the First World War. In 1926 the St Ives Society of Artists was formed (having initially as its gallery Nos. 4 and 5 Porthmeor Studios) and 1938 saw the opening of the St Ives School of Painting.

Large numbers of traditional artists are still working in St Ives and, with the influx of tourists every summer, manage to attract a lucrative market. St Ives, however, owes its international importance to a very different group of artists, who have frequently been in confrontation with the traditionalists. The first of these more advanced figures was the potter Bernard Leach, who came to St Ives in 1920. Leach had just spent a period of study in Japan, and he came here with the Japanese Haji Hamada, who stayed three years. Leach and Hamada are now recognized as two of the greatest potters this century.

Between 1925 and 1942 there worked at St Ives one of the most idiosyncratic of British painters, Alfred Wallis. Wallis was a near-illiterate Devonshire man, who took up painting at the age of seventy to console himself for the loss of his wife. His works, mainly depicting ships, are executed with ordinary decorator's paint on scraps of board given to him by the local grocer. Circumstances were undoubtedly favourable for the development of Wallis's talents. It is unlikely that he would ever have started painting were it not for all the artists he saw working around him. No. 3 Back Road West (plaque), where he owned a rag-and-bone shop and did his painting, was in the heart of Downalong, just a few doors away

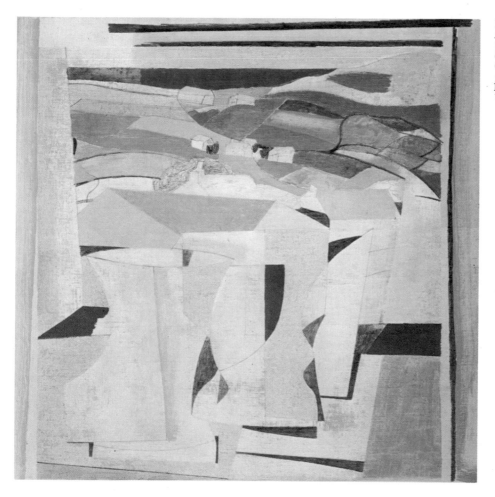

Ben Nicholson
*December 1947
(Trendrine,
Cornwall)*
Oil on canvas,
38·1 × 36·8 cm
Phillips Collection,
Washington

from the Porthmeor Studios. He was discovered here by Ben Nicholson and Christopher Wood on a day-trip they made to St Ives in August 1928. One of the paintings which the two excited artists bought from him on that occasion is now in the collection of Denis Mitchell; it cost them two shillings and sixpence. Wallis's admirers in his lifetime numbered only a handful, however, and he always lived in extreme poverty, under conditions which his biographer Sven Berlin described as 'a disgrace to human life'. He died in 1942; his grave, in St Ives cemetery, is marked by a plaque by Bernard Leach, which describes him as 'Artist and Mariner'.

Whatever the direct influence of Wallis, the example of a painter who successfully managed to transform three-dimensional objects into simple, flat-forms gave considerable encouragement to those artists who were breaking away from conventional modes of representation. This new generation eventually made St Ives the leading centre for abstract painting in this country.

In April 1939 Adrian Stokes and his wife Margaret Mellis bought Little Parc Owles, a large house at Carbis Bay, which is virtually a suburb of St Ives. In August of the same year, just two weeks before the outbreak of the Second World War, Stokes invited two Hampstead friends, Ben Nicholson and Barbara Hepworth, who were anxious to evacuate their children from London, to come and stay with him. Shortly after their arrival they were joined by the constructivist sculptor Naum Gabo, who remained in Carbis Bay until the end of the war, when he emigrated to the United States. The only major abstract painter born in St Ives – and very proud of it – was Peter Lanyon. In a story worthy of Vasari, Stokes had discovered Lanyon in 1937 painting by the roadside, and had encouraged him to attend the Euston Road School of Painting. It was therefore particularly appropriate that in the early 1950s Lanyon in turn became the owner of Little Parc Owles, and stayed here until he died as a result of a gliding accident in 1964.

Alfred Wallis
*Schooner and
Lighthouse*
c. 1928; oil and
pencil on card,
16·5 × 30·5 cm
Collection of
Denis Mitchell

LEFT: Barbara
Hepworth's garden,
St Ives

RIGHT: Little Parc
Owles, Carbis Bay

Of all the British artists who have worked in St Ives, Hepworth and Nicholson have gained the greatest international reputation, and the former was one of the first sculptors to work in a totally abstract idiom. After their short stay in Little Parc Owles they moved briefly to Dunluce House in Carbis Bay, and in 1942 to the nearby and larger Chy and Keris. In 1949 Hepworth bought Trewyn Studios in the centre of St Ives and lived here permanently after 1951, when her marriage to Nicholson was dissolved. The spacious working area provided by this large house was later augmented by the purchase of the Palais de Danse just across the road. Hepworth died in 1975 and today Trewyn Studio, together with its garden, has been turned into a memorial museum; it remains almost exactly as it was in her lifetime. Ben Nicholson stayed on in St Ives until 1958, when he went to Switzerland.

The art of Hepworth and Nicholson represents abstraction at its purest. A more intuitive and painterly approach to non-figurative art was adopted by the so-called 'middle generation' of British painters who came to dominate the art scene in St Ives in the 1950s. One of the first of these was Bryan Wynter (see *St Buryan* and *Zennor*), who moved to St Ives in 1945 and settled near by in Zennor in the following year. Terry Frost, a relative latecomer to painting, arrived in St Ives in 1946, and first lived in a caravan parked along Headland Road in Carbis Bay, just behind Nicholson and Hepworth. Frost registered at the St Ives School of Painting, then no more of an advanced school than it is now, and worked initially in a manner reminiscent of Van Gogh, only producing his first abstract in 1949. He continued to live in St Ives, though intermittently, until 1963.

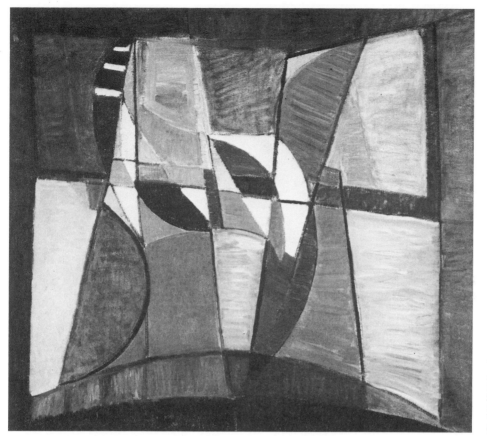

Terry Frost
Blue Movement
1953; oil on
masonite, 110·8 ×
122·2 cm
Vancouver Art
Gallery

In 1947 Patrick Heron rented a cottage for a few weeks on the sea wall in St Ives, and continued to do so every summer until 1955, when he bought Eagle's Nest at Zennor (q.v.). As well as being a leading painter of the 'middle generation', Heron is one of the outstanding post-war British art critics, being, for instance, one of the first to write an intelligent appreciation of Braque. His admiration for Braque is reflected in his own paintings of his Sea Wall cottage, which generally feature a view of St Ives seen through a window or balcony.

The influx of advanced artists into St Ives after the Second World War was bound to antagonize the traditionalists. Thanks largely to Borlase Smart, the two opposed elements in the art colony exhibited together between 1945 and 1948 in the Mariners' Chapel, the new gallery of the St Ives Society of Artists. Disagreements between the two factions resulted in a group of artists, including Lanyon, Wynter and John Wells, exhibiting in the crypt of the chapel. Other alternative exhibiting arrangements for the avant-garde of this time were provided by Endell Mitchell, brother of Denis (see *Newlyn*), in his pub, the Castle Inn, Fore Street, and by G. R. Downing in his bookshop, also in Fore Street. In 1948, the year after the reactionary President of the Society, Sir Alfred Munnings, gave a notorious speech in Newlyn condemning the Tate Gallery's holdings of Matisse, the tensions within the group became fully apparent. At a meeting in the Castle Inn in February of that year, breakaway members decided to form the Penwith Society of Arts, with Herbert Read as its President. Since its inception, the Penwith has been the most serious exhibiting body in Cornwall, and now provides studios and facilities for artists, as well as housing an impressive permanent collection of the St Ives School. Thanks largely to the Penwith, St Ives was put firmly on the artistic map in the 1950s and early 1960s, attracting a large number of artists, critics and dealers, not only from London, but also from New York; the American abstract painters Mark Rothko, Larry Rivers and Mark Tobey all visited St Ives, as did the influential critic Clement Greenberg. By the second half of the 1960s, however, it was already going out of fashion.

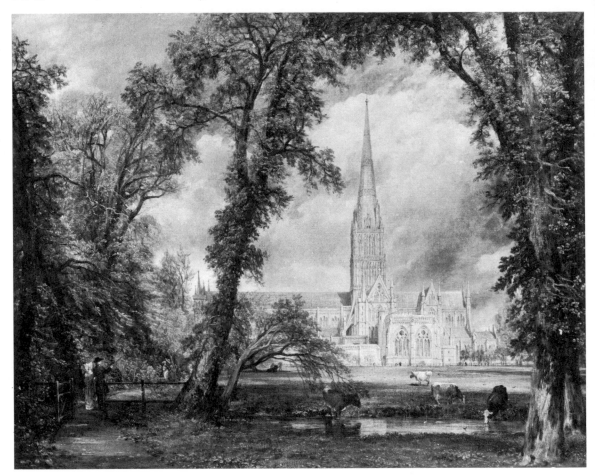

John Constable
*Salisbury Cathedral
from the Bishop's
Grounds*
1823; oil on canvas,
87·6 × 111·8 cm
Victoria and Albert
Museum, London

Salisbury, *Wilts.*

John Constable first came to Salisbury in
1811 as a guest of the Bishop, who had
previously been titular rector of Langham,
near the artist's native village of East
Bergholt in Suffolk. During his stay he
established a close and lasting friendship
with the Bishop's nephew, Archdeacon
John Fisher, who lived at Ledenhall in the
Cathedral Close, and he was a frequent
visitor to the city until the latter's untimely
death in 1832. Fisher bought several of
Constable's works, but the well-known
*Salisbury Cathedral from the Bishop's
Grounds* was painted on commission for the
Bishop himself, to hang in his London
home in Seymour Street. The Bishop, who
appears in the picture strolling along a path
with his wife, liked Constable's work 'all
but the clouds' and said he would have
preferred a clear, blue sky.

This century Salisbury witnessed one of
the most mysterious deaths among British
artists. The victim was the twenty-nine-
year-old Christopher Wood. In 1930, after

returning from France, where he had
produced his first truly mature and personal
works, Wood went to see his family, who
lived at Broad Chalke, just outside the city.
At Salisbury station he was met by his
mother and sister, who found him in a very
agitated state. He claimed that he was being
watched by some strange Algerians, and
insisted on returning immediately to Lon-
don. Whether intentionally or not, he
subsequently fell under a moving train. On
an envelope found in his pocket were
scribbled two enigmatic sentences: 'Are
they positive?', and 'Throwing away is not
big enough proof.' Wood was buried in the
churchyard at Broad Chalke, in a grave with
a headstone carved by Eric Gill.

Stonehenge, *Wilts.*

Stonehenge was used as a major example of
the 'sublime' in Edmund Burke's *Philo-
sophical Enquiry into the Origin of our Ideas
of the Sublime and Beautiful* of 1756. This
undoubtedly influenced the inclusion of
Stonehenge-like structures in *King Lear*

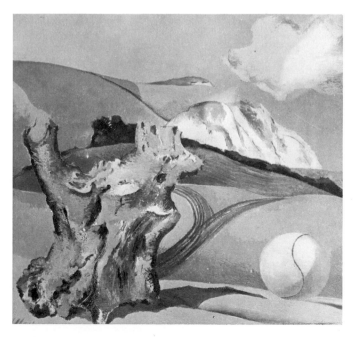

John Constable
Stonehenge
1836; watercolour,
38·7 × 59·1 cm
Victoria and Albert
Museum, London

Weeping over the Dead Cordelia by Burke's friend and protégé James Barry and in other dramatic history paintings of the period. By the 1830s the place had become a favourite romantic site, and it inspired a number of the late works of Constable, who had been a frequent visitor to nearby Salisbury for most of his life. His watercolour of 1836 was shown at the Royal Academy exhibition with the following legend: 'The mysterious monument of Stonehenge, standing on a remote and boundless heath, as much unconnected with the events of past ages as it is with the uses of the present, carries you back beyond all historical records into the obscurity of a totally unknown period.'

More recent artists have been attracted by the formal qualities of Stonehenge as a piece of abstract sculpture as well as by its mystery and antiquity. Photographs of it appeared in the avant-garde publication *Circle* (1937) between writings by Barbara Hepworth and Henry Moore; and in 1971–3 Moore produced a set of prints called *The Stonehenge Suite*.

Swanage, *Dorset*

Paul Nash (see *Avebury*) stayed at Swanage from October 1934 until March 1936 while compiling the *Shell Guide* to Dorset, his favourite county. At first he and his wife were lent Whitecliff Farm, on the outskirts of the town. The view from the farm looking over Ballard Down to the sea is accurately recorded in his *Event on the Downs*; the juxtaposition of the smooth, geometrical form of the tennis-ball and the rugged tree-stump is typical of Nash's art. In February 1935 the Nashes moved to rooms in the centre of Swanage, at No. 2 The Parade, and in the summer of that year briefly contemplated having a house built in the town.

An article by Nash entitled *Swanage, or Seaside Surrealism* appeared in the *Architectural Review* of April 1936. In this he wrote how the town fascinated him with its combination of hideous 'Purbeck-Wesleyan-Gothic' buildings and superb natural scenery.

Paul Nash
Event on the Downs
1933; oil on canvas,
50·5 × 61 cm
Department of the
Environment

Warleggan, *Cornwall*

The painter Graham Ovenden, a member of the Brotherhood of Ruralists, has for some years been transforming his house, Barleysplatt, on Bodmin Moor near Warleggan, into a fairytale castle. Attempting to revive the Gothic Revival, he has taken much of his inspiration for the design of the house from Victorian architects such as Pugin and Burges. Ovenden also has a deep admiration for Victorian painting and photography, which is reflected in his work.

Graham Ovenden's castle, Warleggan

Peter Blake's converted railway station, Wellow

Wellow, *Somerset*

The imaginatively converted Wellow railway station is the home of Peter Blake, one of the foremost British figurative painters; near by is a spacious chapel which he uses as his studio. Both places are filled with the kind of nostalgic bric-à-brac that populates his early work. But his paintings of rock musicians and boxing stars, portrayed as if seen through the eyes of a child brought up on a surfeit of cigarette cards, have now largely given way to works evoking a different form of childhood nostalgia – the world of fairies and Alice in Wonderland. Blake was a founder-member of the Brotherhood of Ruralists (see *Devizes*), a group of artists unashamedly sentimental in outlook, who wish to reassert the traditional values of British painting. The Brotherhood's heroes are naturally the Pre-Raphaelites, and Blake identifies himself particularly with Millais.

Weymouth, *Dorset*

The most distinguished artist born in Weymouth was Sir James Thornhill, who is known chiefly for his decoration of the dome of St Paul's Cathedral (1715–21). He was the son of a wholesale merchant living in Melcombe Regis (the house is now the White Hart Hotel in Nicholas Street).

Shortly after his birth his father absconded, fleeing a debt, and Thornhill was brought up largely by a wealthy great-uncle in London. By 1720 Thornhill himself had amassed a considerable fortune and was able to buy the decaying and uninhabited property of Thornhill, in Stalbridge, where his ancestors had been lords of the manor. Here he erected the present house (now somewhat altered) as a summer residence. He took an active part in local affairs, sat as M.P. for Weymouth and Melcombe Regis,

and was granted the freedom of the town. A royal coat-of-arms painted by Thornhill and given by him to Weymouth now hangs in the Museum of Local History, and a large altarpiece of *The Last Supper* is in the church of St Mary.

Osmington, near Weymouth, was the parish of Archdeacon Fisher, the intimate friend of John Constable (see *Salisbury*). Constable spent part of his honeymoon here in 1816, and painted several views of Weymouth Bay.

John Constable
Weymouth Bay
1816; oil on canvas,
52·7 × 76·2 cm
Museum of Fine
Arts, Boston

Patrick Heron
*Complicated Green
and Violet: March
1972*
Oil on canvas,
182·9 × 304·8 cm
Private collection

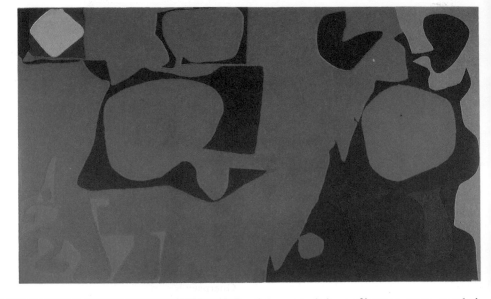

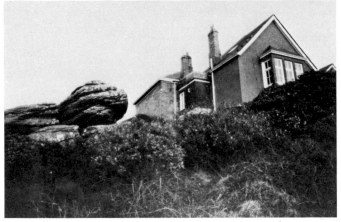

Eagle's Nest,
Zennor

Zennor, *Cornwall*

Zennor and its surroundings are full of both literary and artistic associations. The village inn keeps a book with the signatures of the artists who have stayed there and, in some cases, drawings by them. They include Alfred Munnings, who painted a famous canvas of the inn, and Sir Cedric Morris. Zennor is also associated with two of the most important British painters of the 'middle generation' (see *St Ives*): Bryan Wynter and Patrick Heron. Wynter came to the village in 1946 and went to live in a remote cottage – still only accessible by foot or Landrover – on Zennor Carne. He lived initially on his own, quite unperturbed by the fact that a previous owner of the cottage had been the sinister Aleister Crowley ('The Beast'), well known for his experiments with black magic. 'The landscape I

live among is bare of houses, trees, people,' Wynter wrote in 1962, 'it is dominated by winds, by swift changes of weather, by the moods of the sea; sometimes it is dominated and blackened by fire.' From 1946 until 1955 Wynter's work consisted entirely of recognizable landscapes, painted in a romantic, expressive way. In the words of Heron: 'No one else has so conveyed the bleak, bony, strong mysteriousness of the Celtic Moors.' From 1955 date Wynter's first abstract works, and from 1960 his first mobiles, which he named *Imoos* (Images Moving Out Of Space). These consist of painted silhouettes suspended against a large parabolic concave mirror, the original of which was a discarded searchlight reflector which hung over his fireplace.

Patrick Heron lives at Eagle's Nest, just off the St Ives road outside Zennor. He bought the house in 1956, but had spent five years there as a child when his father Tom, a considerable patron of the arts, ran Chrysede Silks in St Ives. Eagle's Nest is spectacularly embedded in rocks and has a most beautiful garden. Heron's move here seems strongly linked with his first abstracts, some of which were partly inspired by shrubs in bloom. From 1957–8 date his innovatory stripe-paintings; these, as the artist himself realized only later, bore a resemblance to the sunset over the sea, as observed from his Zennor house. In 1963 Heron's art developed a new clarity, with colours contained within sharp if meandering outlines; he has continued in what he terms this 'wobbly, hard-edged style' up to the present day.